Western Art 1600-1800

CHRISTOPHER McHUGH

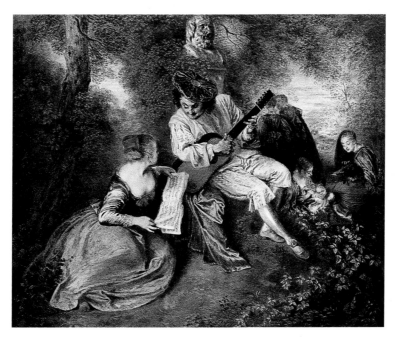

Thomson Learning
New York

ART AND ARTISTS

Ancient Art
Art in the Nineteenth Century
Impressionism
Modern Art
Renaissance Art
Western Art 1600-1800

Cover picture *The Scullery Maid* by Jean-Baptiste-Siméon Chardin. *Glasgow Art Gallery and Museum, Scotland.*

Title page *La Gamme d'Amour* by Jean-Antoine Watteau. *National Gallery, London.*

First published in the
United States in 1995 by
Thomson Learning
115 Fifth Avenue
New York, NY 10003

First published in Great Britain in 1994 by
Wayland (Publishers) Limited

Library of Congress Cataloging-in-Publication Data
McHugh, Christopher.
 Western art 1600-1800 / Christopher McHugh.
 p. cm.—(Art and artists)
 Includes bibliographical references and index.
 ISBN 1-56847-218-8
 1. Art, European—Juvenile literature. 2. Art, Modern—
17th-18th centuries—Europe—Juvenile literature.
3. Art, American—Juvenile literature. 4. Art, Modern—
17th-18th centuries—United States—Juvenile literature.
[1. Art, Ancient. 2, Art, Modern, 17th-18th centuries.
3. Art appreciation.] I. Title. II. Series: Art and artists
(Thomson Learning (Firm))
N6756.M35 1994
709'.03'2—dc20 94-29041

Printed in Italy

Picture acknowledgments
The photographs in this book were supplied by: Archiv für Kunst und Geschichte *title page*, 4, 7, 12, 13 (both), 17, 24 (both), 25, 26 (left and lower right), 27, 29, 34, 35 (both), 36, 42, 44 (right); Bridgeman Art Library *cover*, 5 (left), 8, 9, 10, 15 (both), 16, 18 (both), 19, 23, 28 (right), 31 (both), 33, 40, 41; Tony Stone Worldwide 26 (upper right); Visual Arts Library *cover* (background), 5 (right), 6, 11, 20, 28 (left), 30, 32, 37, 38, 39, 44 (left); Wayland Picture Library/National Gallery 14, 21 (right), 45, /National Maritime Museum 21 (left), /National Gallery of Scotland 22.

CONTENTS

1 INTRODUCTION

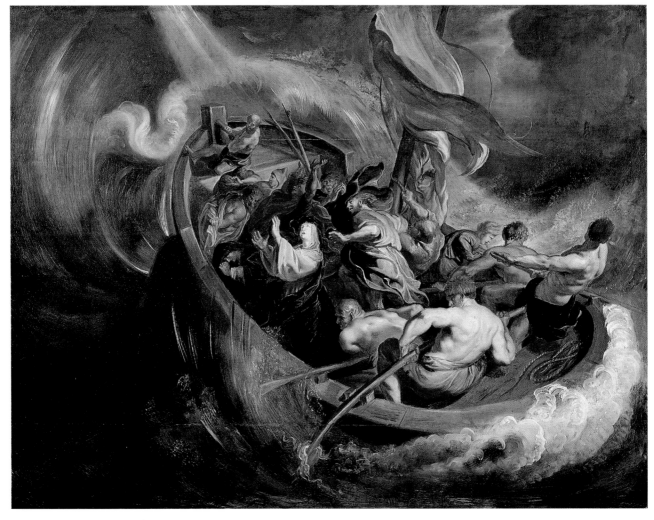

This is a book about art in Europe and Europe's extension into the "New World" of the American colonies between the years 1600 and 1800. It was during this period that parts of the British North American colonies first became an independent country, the United States of America. Many interesting and exciting artists worked during this period, using enormously different ways of making art. One reason for all the variety in European art during those times was that huge changes were occurring in the way people thought and in the lives they led. Some of the changes will be explained later as different artists and styles of art are examined.

Between 1600 and 1800 nearly every aspect of life was affected by the immense changes in the beliefs that people held (religion and philosophy), the way decisions were made (politics), and the kinds of work people did. This was a time of many revolutions, including the one in France in 1789 that overthrew the French king, and others that completely changed the way people farmed the land and made the things they needed.

Throughout the two hundred years looked at in this book, arguments and even wars were fought over the power of the Catholic Church,

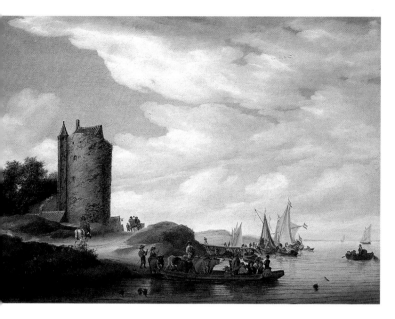

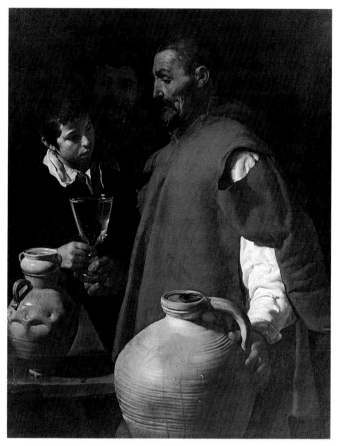

Above *River Estuary with Watchtower* by the Dutch artist Salomon van Ruysdael (c. 1602-1670), uncle of Jacob van Ruisdael (see page 20). The artist has painted the features of the landscape and the human activities taking place within it. *Johnny van Haeften Gallery, London.*

Above *The Water Seller of Seville* by the Spanish artist Diego Velázquez. We can see how brilliantly Velázquez painted the texture of the man's rough clothes and the clay pots. *Apsley House, London.*

Left *The Miracle of St. Walpurga* by the great Flemish painter Peter Paul Rubens (see page 11). All the parts of this picture – the swirling sea, straining bodies, and flapping sail – build up a powerful, dramatic effect. *Museum der Bildenden Künste, Leipzig, Germany.*

which had its headquarters in Rome. Power gradually moved away from the middle of Europe, westward and northward to countries such as Spain, France, the Netherlands, and Great Britain. These nations built up great wealth through overseas trade, and their empires spread over many parts of the world.

In order to understand the changes that took place in art in the seventeenth and eighteenth centuries, it is a good idea to take a brief look at the period before and see what was happening then.

Within the previous two hundred years, a period of European life and art called the Renaissance had taken place. Renaissance means "rebirth," and during that time (from about 1400 to 1520) people's thoughts turned back to the days of ancient Greece and Rome, known as the classical period. In the Renaissance people felt they were returning to the values of the ancient Greeks and Romans, and one of the results of this revival of "classical" thinking was that artists became much more interested in what was happening in the world around them, especially in all kinds of human activity.

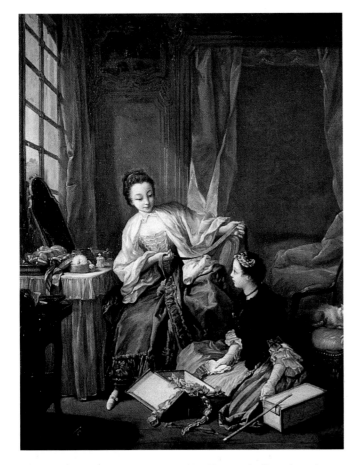

The Modiste by the French artist François Boucher. In this bedroom scene with mistress and maid, Boucher depicted the fondness for pleasure and fashion that was such an important part of the rococo style (see pages 25-28). *Wallace Collection, London.*

Women artists

Before the sixteenth century most European artists were not celebrated for originality or individuality, and art was mostly of the kind known as craft art. Women, often working in groups in convents, produced many kinds of art, such as weaving and tapestry. Although women had far less freedom and power than most men, during the Renaissance a few women began to achieve fame as artists, especially those who were trained by fathers who were artists. Sofonisba Anguissola (c.1527–1625) was one of the first women to make a name for herself as a professional artist in Italy, later becoming a court painter to Philip II in Spain. Other women found success in the early seventeenth century, such as Artemisia Gentileschi (c.1597–after 1651) and Elisabetta Sirani (1638–1665) in Italy and others in the Netherlands, including Judith Leyster (see page 19). In the eighteenth century, artists such as Angelica Kauffmann (see pages 31 and 44) found success in England, and Louise Élisabeth Vigée-Lebrun (1755-1842) was a well-known portrait painter in France. In North America, mother and daughter Ellen and Rolinda Sharples, among others, earned their livings as portrait painters at the end of the century.

During the Renaissance, new techniques were developed by artists and architects to show realistically the appearances of three-dimensional objects on flat surfaces such as walls or wood panels. Portraits and lifelike depictions of real people became more popular and gradually artists and their customers (or patrons) became more interested in these "human" subjects. Until then they had been concerned only with Christian religious themes. Several small city-states in Italy, such as Florence, led the way

with these new ideas in thinking and art, but soon the ideas spread throughout Europe. At its height the Italian Renaissance produced great artists such as Leonardo da Vinci, Michelangelo, and Raphael.

After this high point, however, it was difficult for painters and sculptors following them to improve upon the marvelous works created by such talented artists. Throughout the 1500s many artists copied or exaggerated the work of earlier examples. This period is usually called

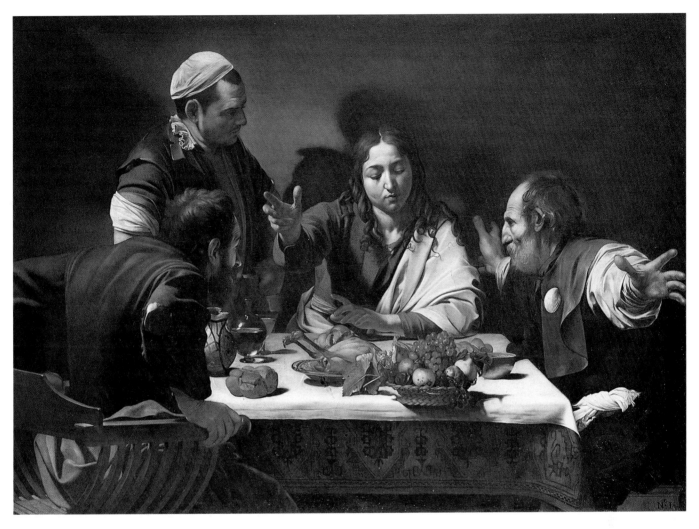

Supper at Emmaus by Michelangelo Merisi da Caravaggio. This scene from the New Testament of the Bible shows some of the prominent features of Caravaggio's work, such as the dramatic gestures of the figures, the use of ordinary people as models, and the strongly contrasted light and shadow. Caravaggio's work was famous in its own time and had a strong influence on other artists. *National Gallery, London.*

"Mannerist," because artists imitated the "manner" in which the great artists of the High Renaissance had worked.

At the end of the 1500s a very original artist appeared in Italy. This was Michelangelo Merisi da Caravaggio (1573–1610), who ignored many of the lessons of the earlier masters. He usually worked by looking directly at his subjects, painting them as they were in startling and honest detail. He often used poor people from the street or drinkers from taverns as his models, paying them to come and sit in his studio. Perhaps the most daring change he introduced was his use of light and dark in painting. Caravaggio exaggerated this to the extreme, making shadows intensely black and lightening the lit areas so that they seemed to glow out of the darkness. Caravaggio's technique of using strongly contrasted shading influenced artists all over Europe and became one of the most important features of much of the art produced during the next hundred years.

2 THE DRAMA OF SAVING SOULS

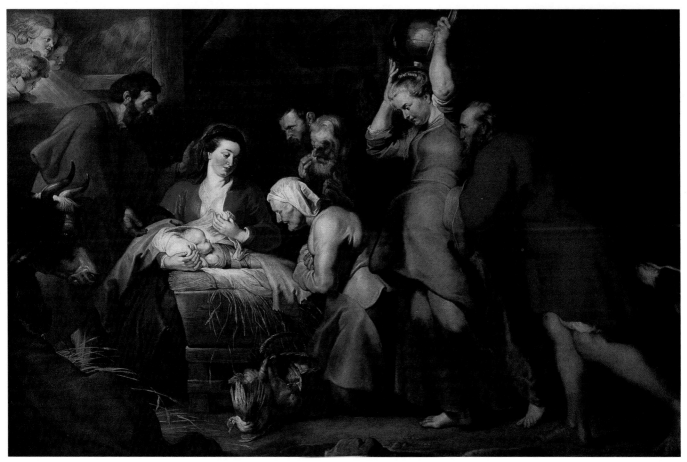

Above *Adoration of the Shepherds* by Peter Paul Rubens. In this painting of the nativity, the figures – for example, the one leaning steeply in on the right and the other one curving in on the left – focus attention on the brightly lit infant Jesus in the manger. *National Gallery of Scotland, Edinburgh.*

Right *Immaculate Conception* by Giuseppe (José) Ribera (1588-1652). The dove hovering over the Virgin Mary's head depicts the "Visitation of the Holy Spirit," making her the mother of Jesus Christ. Ribera was a Spanish painter working in Italy at the height of the Counter-Reformation. *Convento Agustinas Recoletas, Salamanca, Spain.*

The 1600s in Europe are often called the Baroque age. Baroque is not an easy word to explain; sometimes it is used to suggest that the ideas and art of that period are over-dramatic and lack honesty and seriousness. Baroque came from a French word meaning "misshapen pearl," and it was used to suggest both the richness and irregularity of art and design in this period.

One of the most important reasons for the development of the Baroque style was the Christian religion. In northern Europe in the early 1500s, dissatisfaction with the way the Roman Catholic Church was being run led to a revolt against the authority of the Church. This was known as the Reformation, and it posed a serious threat to the power of the Pope and to the Catholic Church itself. In response to this

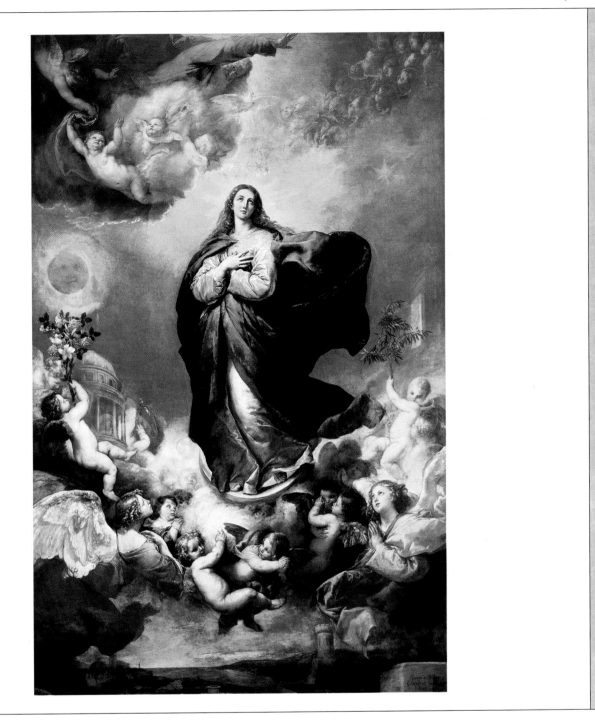

challenge, the Pope and senior officials of the Church tried to prevent the spread of these new "Protestant" beliefs, in what came to be known as the Counter-Reformation. The Baroque style of art, with its drama and emotional appeal, was developed as a means by which the Counter-Reformation could win its fight to "save souls" and return them to the Catholic faith.

Baroque architecture first appeared in Italy in the late 1500s, but it soon spread through the next century to other parts of Catholic Europe, particularly Spain, southern Germany, and Austria. The Baroque style of art impressed the viewer with its large scale and a busy combination of effects that added up to an exciting whole. Inside Baroque churches, architectural features such as columns and

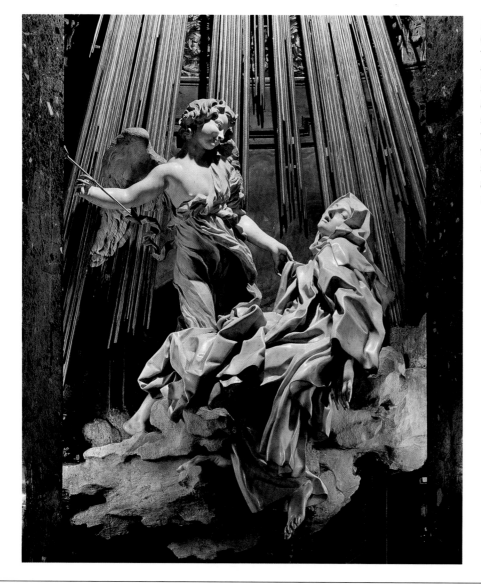

Ecstasy of Saint Theresa by Gianlorenzo Bernini (1598-1680). This sculpture was commissioned for the altar of a church in Rome. It is a striking example of how Baroque artists were required to use their skills to amaze and overwhelm the viewer. Often the purpose for this was to make people believe more strongly in the power of the Church and the ideas of the Catholic faith. *Santa Maria della Vittoria, Rome.*

arches were made more elaborate, with rich decoration and paintings showing saints, angels, clouds, and images of God.

One of the most famous Italian Baroque architects was Francesco Borromini (1599–1667) and one of the best-known sculptors was Gianlorenzo Bernini (1598–1680). Bernini's sculpture of the Ecstasy of Saint Theresa at the Church of Santa Maria della Vittoria in Rome is a good example of how Baroque sculpture was designed to excite the emotions of the viewer. The gold-covered rays of light behind and the strange, soft shape of stone upon which St. Theresa sits (a cloud) give the viewer a sense that the sculpture is floating. St. Theresa's expression shows her feelings of pain and yet also of happiness. The folds of her clothes tumble over her body and the cloud is almost like a cascade of water. An angel stands over her in the act of piercing her heart with an arrow, to represent the heavenly vision that has affected her so powerfully.

As the seventeenth century progressed and the power of this dramatic style of art and architecture proved successful in helping the Catholic Church to win back followers to its faith, others, too, began to make use of Baroque art. Monarchs and influential people

Two Boys Eating a Pie by Bartolomé Esteban Murillo (1617-1682). Murillo was one of the last great seventeenth-century Spanish artists painting in Seville. He painted mostly religious subjects, but this picture shows another side of his work, depicting beggar children in a way that tends to hide the pain and suffering of the real life in the streets. *Bayerisches Staats Gemaldes, Germany.*

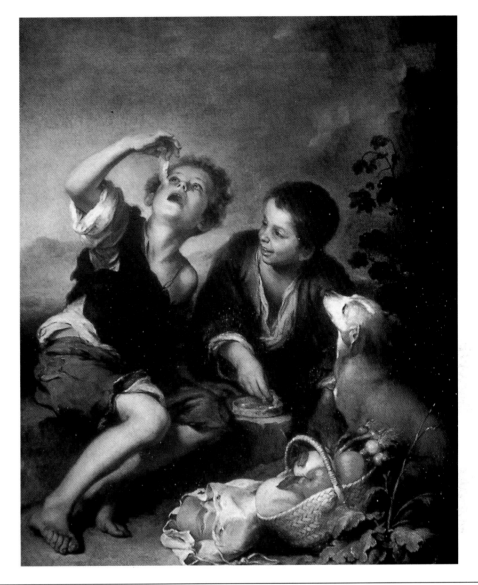

began to employ artists to create works for them that displayed their wealth and power.

One of the best known artists of the early 1600s, Peter Paul Rubens (1577–1640), was based in the city of Antwerp, in the country known today as Belgium. After beginning his training as a painter in Antwerp, Rubens then went to Italy to learn about the work of the Renaissance masters and the Italian Baroque style. Back in Antwerp he became a court painter to the Spanish rulers of the Netherlands and began a career that made him famous, rich, and powerful. He painted huge pictures for churches and palaces showing stories from the Bible and from classical mythology or grand scenes depicting kings and princes. Sometimes he painted straightforward portraits of wealthy patrons.

So many people wanted paintings by Rubens that he needed other artists to work for him, helping to produce the pictures that had been ordered. This was the usual way for successful artists to keep pace with the demand for their work but, even by the standards of the day, Rubens's team of assistants was large and especially skillful. One of his most famous assistants, more than twenty years his junior, was Anthony Van Dyck (see page 29). Rubens's

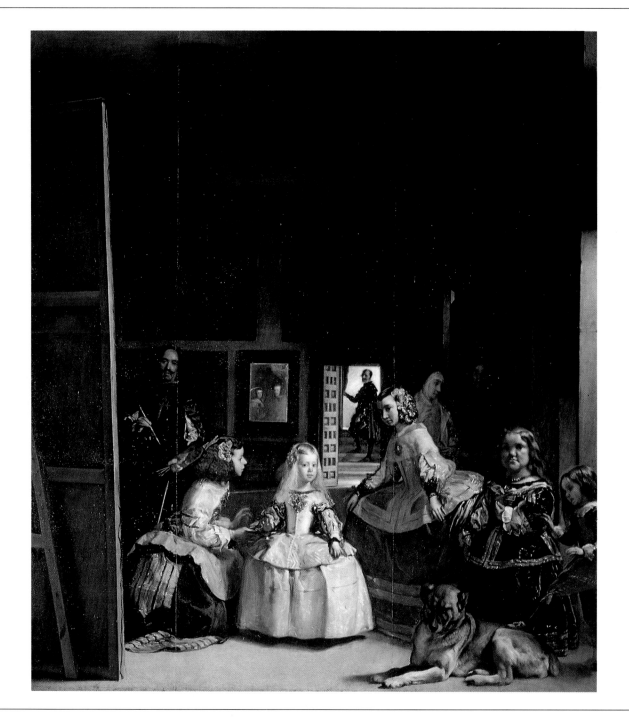

fame spread all over Europe, and on a visit to Spain he met and became friends with a court painter there by the name of Diego Velázquez (1599–1660).

Velázquez was the most successful of a large number of painters employed in the service of King Philip IV. Many painters in Spain were employed by the Catholic Church to carry out the work of the Counter-Reformation. Some of these artists had been influenced by the style of Caravaggio (see page 7), painting pictures with dark shadows and glistening highlights. Francisco Ribalta (1565–1628) was one, and Giuseppe (José) Ribera was another – although the latter spent much of his career in the Italian city of Naples, which was at that time ruled by Spain. Francisco de Zurbarán

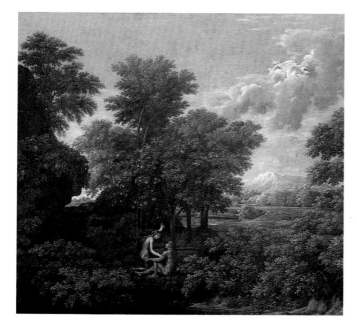

Above *Spring in Paradise* by Nicolas Poussin. In this view of the Garden of Eden, where Eve tempts Adam with very large apples from the nearby tree, Poussin was trying to portray the idea of a perfect world, with carefully arranged trees, clouds, and distant views of mountains and a river. *Musée du Louvre, Paris.*

Left *Las Meninas* by Diego Velázquez. This picture is often considered to be one of the greatest European paintings of its time. Velázquez depicted not only the young princess (the Infanta Margherita) and her Maids of Honor (Las Meninas), but also the King and Queen of Spain (her parents) in the mirror on the back wall, other courtiers in attendance, and himself. *Museo de Prado, Madrid.*

(1598–1664) and Bartolomé Esteban Murillo were Spanish painters who made their names in the southern town of Seville. At that time Seville was the biggest and wealthiest city in Spain, rich with treasures brought back from the Spanish colonies in the Americas. The style of Zurbarán's art was harsh and stark; Murillo's was softer and more emotional.

El Greco (1541–1614)
Domenikos Theotokópoulos was born on the island of Crete, where he trained as a painter of icons (Greek religious pictures). He then traveled to Italy, where he learned the techniques of late Renaissance painting. Finally he moved to Spain, where he became known as El Greco – Spanish for "The Greek." His best-known paintings are very dramatic, with elongated faces and figures full of nervous tension, painted in powerful, often violent colors. El Greco's passionate and emotional style of art had a strong influence on early Baroque art in Spain. Perhaps because of his unusual background, he has remained, essentially, a unique artist. El Greco's remarkable vision is shown in his *Christ on the Mount of Olives* (above). Notice the exaggerated lighting, strong colors, distorted forms, and dramatic composition. *National Museum of Fine Art, Buenos Aires, Argentina.*

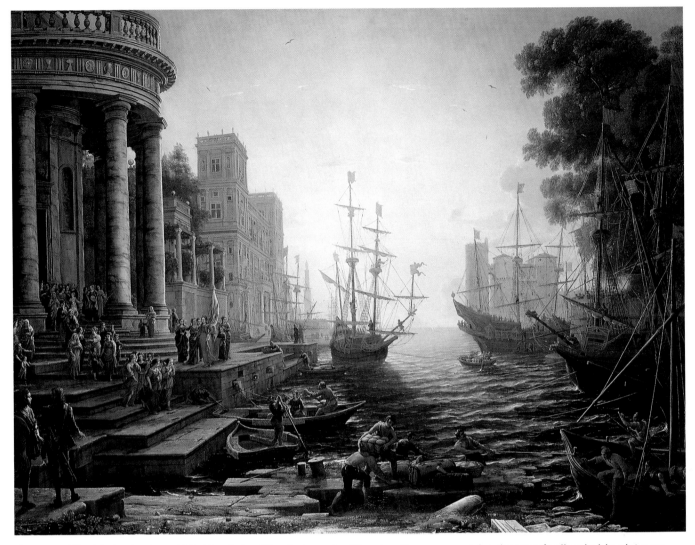

Seaport: The Embarkation of St. Ursula *by Claude Lorrain. Claude often conveyed a dreamy feeling in his pictures. He usually achieved this effect through the way he showed the light in his painting. In this picture of a busy seaport, all the buildings, boats, and people are set against the warm glow of the sun shining over the sea.* National Gallery, London.

In the 1600s, artists in France were also influenced by Caravaggio's style of painting. Georges de La Tour (1593–1652) is one of the best-known of these French artists. He mostly painted scenes from religious stories, with figures in dark rooms lit by the glow of a candle or fire. Other French artists painted in the more usual energetic, Baroque style; they include Simon Vouet (1590–1649), Philip de Champaigne (1602–1674), and Charles Le Brun (1619–1690). Vouet was the most successful painter of interior decorations (on walls and ceilings) in the first half of the seventeenth century. Many of the leading painters of the next generation studied painting as assistants in Vouet's studio, including Le Brun who, along with other artists of the same time such as the three Le Nain brothers, became a member of the French Academy of Painting and Sculpture, founded in 1648.

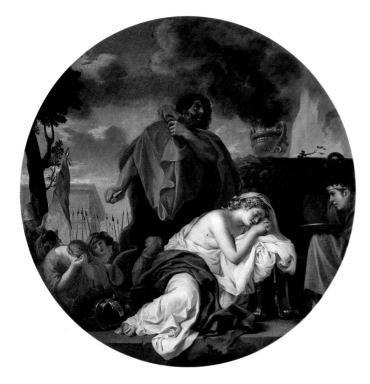

Above *Sacrifice of Jephthah* by Charles Le Brun. Like many French artists of his time, Le Brun studied the Italian masters in Rome as part of his training. He later rose to the top of his profession, becoming Director of the French Academy. *Uffizi Gallery, Florence.*

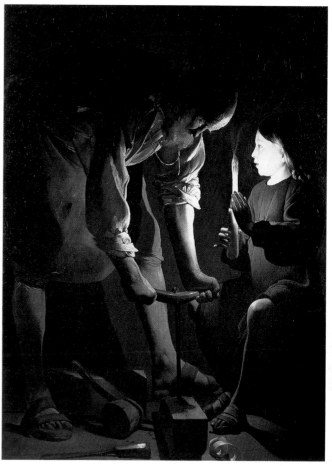

Above *Christ with St. Joseph in the Carpenter's Shop* by Georges de La Tour (1593-1652). La Tour was one of the French artists most influenced by Caravaggio's use of light and shadow, although he probably discovered this in the work of Dutch followers of Caravaggio based in Utrecht (see Honthorst's *A Feast* on page 19). *Musée du Louvre, Paris.*

In terms of their influence on later artists, however, the most important French painters of the 1600s were probably Nicolas Poussin (1594–1665) (see page 13) and Claude Gellée (also known as Claude Lorrain, 1600–1682). These two artists spent much of their working lives in Italy, especially in and around Rome. Poussin and Claude both concentrated on painting scenes from the Bible or from classical mythology, set in open spaces, often with large landscape views in the background. Traditional artistic rules led both artists to organize their subject matter into an order that seemed more pleasing than the apparent disorganization of real landscape. They would each make sketches of the countryside outdoors so that they could later rearrange the elements with, in Poussin's case, more simplicity and balance and, in Claude's case, more mystery and atmosphere.

3 THE WORLDLY VIEW

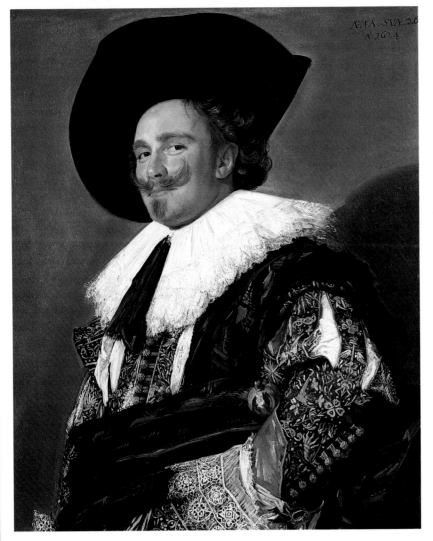

Left *The Laughing Cavalier* by Frans Hals (c. 1581-1666). This is one of the artist's best-known paintings. In it he took the opportunity to show off his painting skills, showing the intricate detail of embroidery and lace. The expression on the cavalier's face and the angle of his head give the picture a sense of energy and life. *Wallace Collection, London.*

Right *The Night Watch*, by Rembrandt van Rijn (1606-1669). This famous painting, more properly known as *The Company of Captain Frans Banning Cocq*, shows a small band of soldiers gathering behind its captain and lieutenant at the very moment of the order to march. It was one of many paintings of the volunteer militia enlisted to defend Amsterdam. Each man paid according to the importance given to his portrait. *Rijksmuseum, Amsterdam.*

One of the places where the Protestant Reformation had a strong effect was in the Low Countries, the part of Europe today called the Netherlands. In the latter part of the 1500s, all of the Low Countries, including the southern part, now called Belgium, were ruled by Catholic Spain. The northern provinces of the Low Countries, however, with their busy merchant towns, joined together to break free from Spanish control and eventually succeeded in establishing an Independent Dutch Republic. The Dutch began to organize their affairs as a separate, free country from before the beginning of the seventeenth century. Freedom meant not paying heavy taxes to the Spanish Crown, and it meant that Dutch citizens could make their own laws and follow their own religious beliefs in the ways they chose.

Freedom from Spanish rule had enormous effects upon life in the free Dutch state, and the art of the period shows these effects very clearly. Many earlier, beautiful rich church pictures had already been destroyed in the religious conflicts of the Reformation, and the

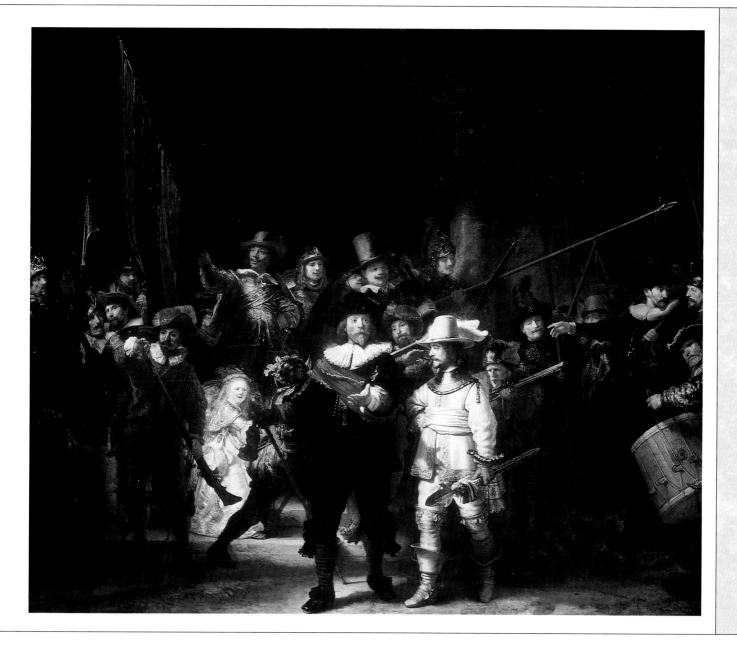

changed atmosphere of the times meant that religious pictures had to be quieter and more solemn. Under the new Dutch rule the middle classes, mostly merchants who had become wealthy from successful trading, had a much more powerful role in society. This was a kind of rule by the people, or "democracy," a political system that most of the Western world now accepts as normal, but which was a new and daring development at that time. It meant that power and wealth were shared between a much larger number of people. Artists no longer worked for one or two fabulously rich patrons, but sold their work to a larger number of citizens.

Some artists still produced pictures based on the styles and subjects of Italian art of the 1500s, but gradually new types of painting became more popular. The most popular was portraiture, for which there was an ever-growing demand. One of the most famous and successful portrait painters was Frans Hals (c.1581–1666), who worked in the town of Haarlem, near Amsterdam. Hals managed to give his paintings of the people around him a

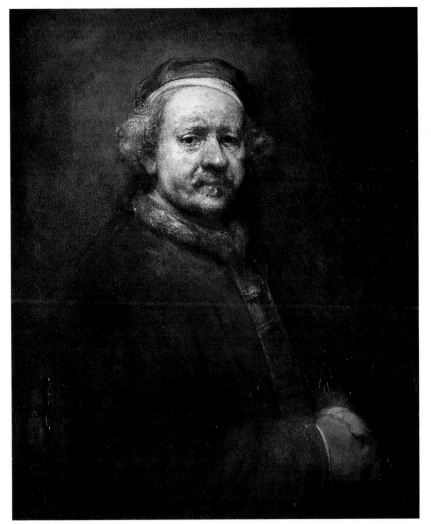

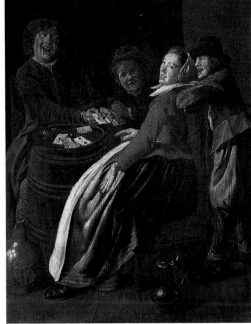

Above *A Game of Cards* by Judith Leyster. She often painted people enjoying themselves. *Musée des Beaux Arts, Rouen.*

Left This self-portrait by Rembrandt is thought to be his last. In it, perhaps, we can see portrayed his feelings of loneliness at the end of his life. *National Gallery, London.*

feeling of exuberance and vitality. He painted rapidly, showing his subjects in natural positions as if he had caught them in the middle of a movement, similar to the way a photograph can catch the appearance of movement today. Hals sometimes painted portraits of groups of people together, a type of picture that had already become popular; for example, as a way of recording volunteer militias. Militias were small local armies employed to defend towns. Hals gave this type of picture a new sense of energy and excitement, but a younger artist, Rembrandt van Rijn (1606–1669), took the idea even further with his huge, famous painting of an Amsterdam militia – *The Night Watch*. This dramatic scene shows the group with their leader, apparently just at the moment of going into action.

Rembrandt is thought by most people to be one of the greatest painters of the period. He tried many different types of painting and had considerable success in his early career. His style owed a good deal to the exaggerated light and shadow of Caravaggio (see page 7), brought to the Netherlands by artists such as Gerrit van Honthorst (1590–1656) and Hendrick Terbrugghen (1588–1629). Although Rembrandt's first successful paintings were religious pictures, his real fame came from his portraits of the wealthy, middle-class citizens of Amsterdam, and much of his wealth came from the sales of the less expensive engraved prints.

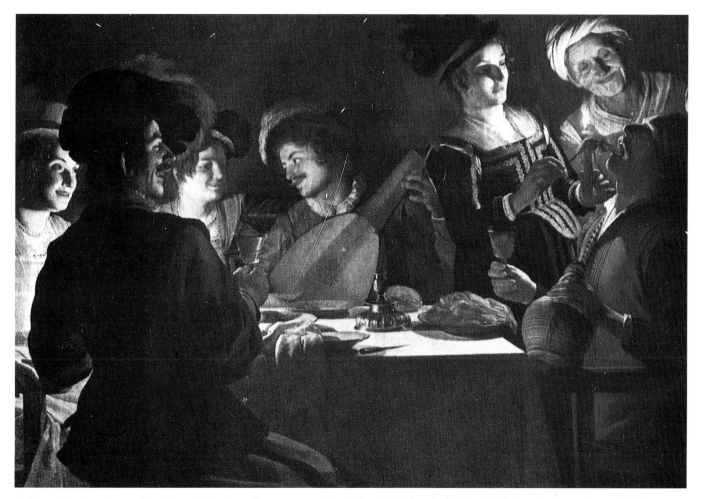

A Feast by Gerrit van Honthorst. Honthorst was one of the Utrecht School of Dutch artists who were foremost in bringing Caravaggio's influence from Italy to the Netherlands. *Uffizi Gallery, Florence.*

Rembrandt, however, is perhaps most admired for the series of self-portraits that he painted throughout his career, even toward the end of his life, when his work had fallen out of fashion and he had lost all his money. He did not paint these self-portraits for sale, but more for his own interest, and perhaps to demonstrate his skills to potential customers and to teach his technique to pupils. They leave us a fascinating and very moving record of his life, from the pride of his youthful success to the pain of his poor old age, when all of his family had died, leaving him finally alone.

Women still had nothing like the freedom and opportunity of men, even in the Dutch Republic. Some, however, did manage to make a name for themselves as artists, often specializing in portraits or domestic scenes – which became a very important type of painting in this period. Judith Leyster (1600–1660) is perhaps the most famous example. She worked in Haarlem and may well have been a pupil of Frans Hals.

There was a great deal of competition among artists in this period as they attempted to win customers from one another. Increasingly, artists specialized in one kind of painting or another, and clear types or "genres" became evident. These included portraits, landscapes, sea pictures, still lifes, and scenes from everyday life. These pictures later became known as genre pictures.

4 SCENES FROM DUTCH LIFE

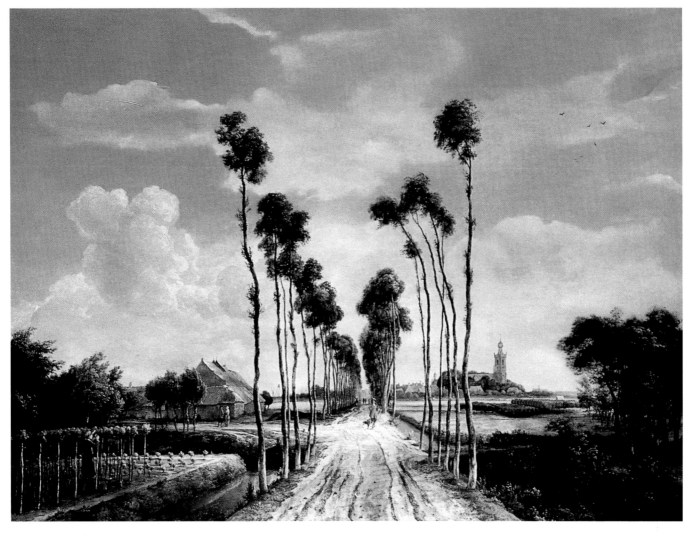

Landscapes only became an important type of painting in the 1600s. Poussin, Claude, and others in France and Italy painted idealized scenes, often with mythological characters providing a story to fit the landscape background. The great Baroque artist Rubens (see page 11) also produced some fascinating landscape pictures toward the end of his life.

Dutch artists, however, began organizing their pictures of the countryside with very different ideas in mind. Early examples, such as Esaias

van de Velde (c.1591–1630) and Hendrik Avercamp (1585–1634), painted pictures showing people engaged in real activities in the countryside. Later artists developed this in two ways, either concentrating on what people were doing or on the appearance of the landscape itself. Several extremely skillful artists produced beautiful landscape views that focused clearly on the appearance of weather and light and their effects on the land itself. Jan van Goyen (1596–1656), Jacob van Ruisdael (1628(29)–1682), Meindert Hobbema (1638–1709), and Albert Cuyp (1620–1691) are just a

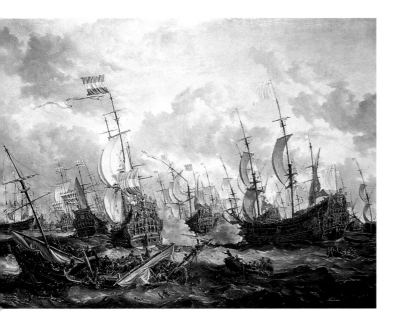

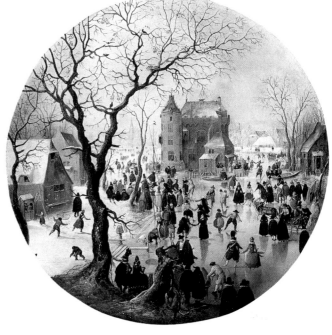

Above *Four Days Fight* by Abraham Stork. This dramatic scene shows a sea battle between the Dutch and English. Naval power and warfare were extremely important for nations like these, depending as they did on sea trade and an expanding empire for their wealth. *National Maritime Museum, London.*

Above *A Winter Scene with Skaters near a Castle* by Hendrik Avercamp. This is a genre painting. It shows townsfolk enjoying everyday activities, in this case, skating on the frozen Dutch waterways. *National Gallery, London.*

Left *The Avenue, Middelharnis* by Meindert Hobbema. Painted in 1689, this is an unusually symmetrical landscape. The honest detail such as the dirt road, the man tending his fruit trees, and the low, flat horizon indicate the new sense of realism that Dutch artists were beginning to show in their work. *National Gallery, London.*

few of the well-known artists who produced landscape paintings. These were usually on a small scale, and they show the increasing interest in pictures presenting a moody or atmospheric vision of the countryside.

The Dutch fascination for pictures of the sea and ships is easily understood when one remembers the vital importance of seafaring for the survival of the country. The Low Countries are very flat and very low. Much of the land that is now farmed had to be won back from the sea by the ingenious building of walls and drainage ditches. The wealth of the new Dutch Republic came from its energetic sea trading with other parts of the world. Simon Vliegher (1600–1653), Willem van de Velde the Younger (1633–1707), and Abraham Stork (1630 or 1635–1710) are among the most famous artists specializing in paintings of ships and the sea. So accurate are many of these pictures in their detail that they are often used now by people who want to know how ships were built in those days or to understand the battle tactics of a particular sea fight.

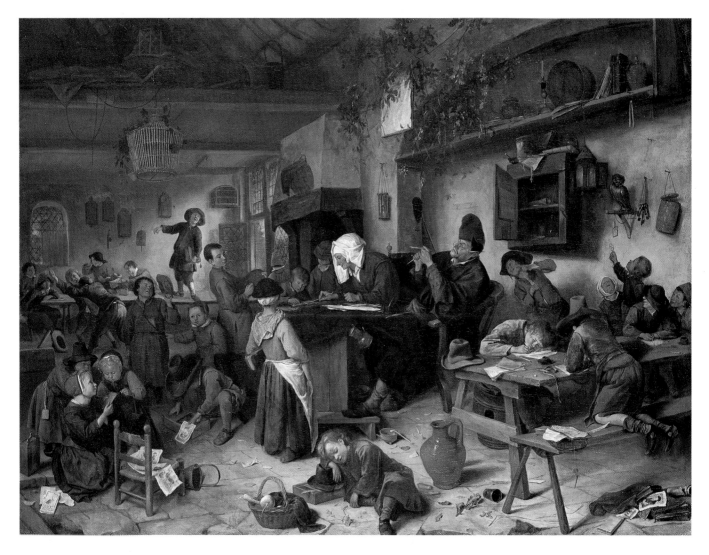

A School for Boys and Girls by Jan Steen. This painting of a school classroom, like the skating picture on page 21, is also a genre painting. Seventeenth-century Dutch genre pictures convey a message; in some, the message is serious, but in this one it is amusing. *National Gallery of Scotland, Edinburgh.*

Other Dutch artists specialized in painting pictures of towns. The explanation for the growing interest in these kinds of pictures is quite simple. The citizens of the bustling merchant towns, with their new, shared wealth and power, had a great deal of pride in their cities. Wealthy businessmen and women wanted to celebrate what was going on in their towns and were ready to pay artists for pictures they could hang on the walls of their homes.

Genre pictures are not quite as simple and straightforward as they may seem. Although they did celebrate the facts of Dutch life and the textures, details, and look of everyday objects, they also did something more. In nearly all the genre pictures there is a lesson about the right and wrong way of behaving, or a "moral." There had been a tradition of this kind of painting in the Netherlands for hundreds of years, but never before did the artists manage to depict the

Woman and Maid with a Pail in a Courtyard by Pieter de Hooch. Genre pictures included scenes of people both indoors and out. In this painting, de Hooch, who specialized in town courtyard scenes, concentrated on the texture and pattern of the various materials that make up the view, such as bricks, tiles, the brass pail, and so on. *Hermitage, St. Petersburg.*

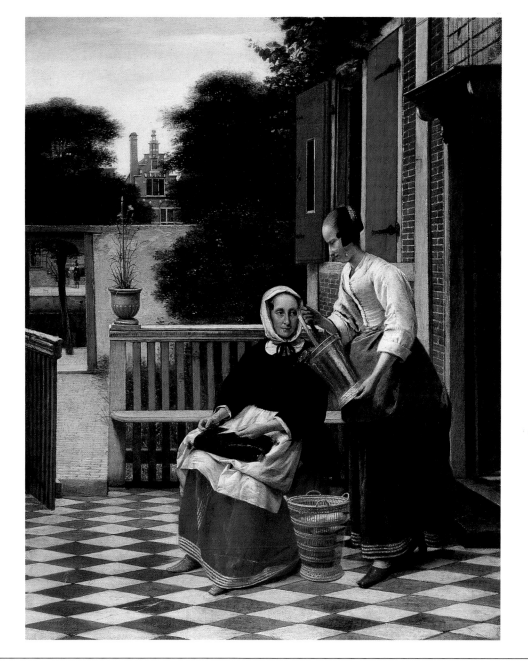

everyday scenes with such startling realism. There were many artists who produced beautiful, entertaining, and disturbing pictures of this kind. Besides earlier examples by Terbrugghen and Honthorst, who had studied in Italy, other artists who specialized in this kind of picture included Gerard Dou (1613–1675), Gerard Ter Borch (1617–1681), Jan Steen (c.1626–1679), Pieter de Hooch (c.1629–after 1684), and Jan Vermeer (1632–1675).

Another subject in which the Dutch artists of the new Republic specialized, and for which they set a new measure of excellence, was the still life. Still lifes are pictures that show an arrangement of objects, usually on a table. The still life is a very ancient type of picture; many were found in the houses of wealthy Roman citizens at Pompeii, Italy, preserved for centuries because they had been buried under the volcanic ash that covered the town when Vesuvius erupted in A.D. 79.

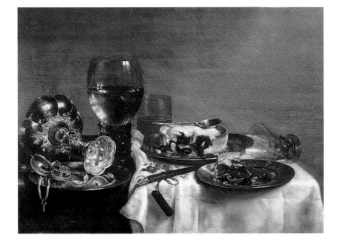

Above *Breakfast Table with Blackberry Pie* by Willem Claesz Heda. This still life shows the artist's skill in depicting simple objects. *Gemäldegalerie Alte Meister, Dresden, Germany.*

Right *Allegory of Painting* by Jan Vermeer. This picture indicates how complex Vermeer's art could be. The scene in a painter's studio symbolizes the art of painting specifically and human endeavor generally. *Kunsthistorisches Museum, Vienna.*

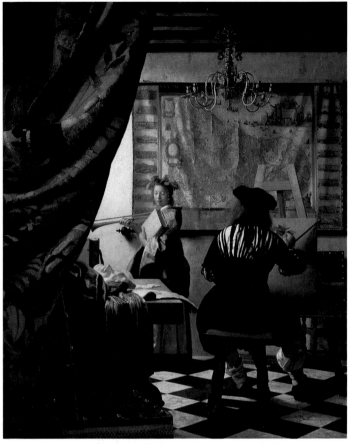

Dutch still life artists such as Pieter Claesz (c.1597–1661), Willem Claesz Heda (1594–c.1680), and Willem Kalf (1619–1693) demonstrated their skills in depicting the textures and surfaces of objects made from glass, metal, and wood and by painting various foods. At first these pictures, like genre paintings, may seem simply to be opportunities for the painter to show off skills, but again there is usually a hidden meaning. Nearly all still life pictures of this time show some of those worldly pleasures that only success and wealth can bring, but always they remind the viewer that these worldly pleasures do not last and that all humans must eventually die. These paintings carry a Christian moral message, namely that behavior in life will affect what happens to the soul after death. Sometimes this reminder of death is obvious, but sometimes it is disguised, such as in maggots eating their way into fruit.

Jan Vermeer (1632–1675)

Jan Vermeer was one of many Dutch artists who needed more than one job to earn a living. Very little is known about his life and only about 35 of his paintings still exist. He lived in the town of Delft and specialized in painting interior scenes, often focusing on the detail and texture of materials such as cloth, bread crusts, and even brass furniture tacks. He used a device called a camera obscura, which projected an image of the real world onto a surface, similar to the way a slide projector works. This device helped him to paint pictures that look amazingly real by showing exactly how the light appeared in his chosen view. For many years Vermeer's paintings were overlooked, but in the nineteenth century their worth was rediscovered and today he is considered by many people to be one of the greatest of all European painters.

5 THE DRAMA BECOMES A DANCE

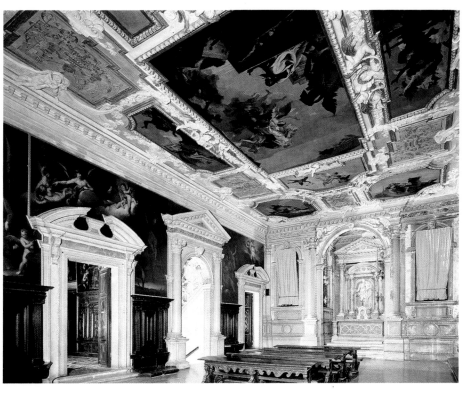

This fantastically decorated room by Giovanni Battista Tiepolo is a marvelous example of the richness of rococo interior design. Tiepolo's paintings on walls and ceilings and the elaborate, gilded plaster moldings create a sense of space and elegance.
Grande dei Carmini, Venice.

In the 1700s a change in people's attitudes was spreading across Europe, and the desperate battle of the Counter-Reformation to reclaim the souls of believers for the Catholic Church became less urgent. In France the great era of Louis XIV, the "Sun King," with all its grandeur and show of power (such as his palace at Versailles), gradually gave way to more pleasurable interests for the wealthy aristocrats of the powerful European nations.

The word used to describe the feeling and style of this less dramatic and more joyful period is "rococo." It comes from a French word meaning "rock work" and refers to the delicate, complicated patterning of interior decoration during this period. Designers and artists were employed to decorate the interiors of houses with elaborate plasterwork and exotic paintings on walls and ceilings. As with the Baroque period, great time and effort were spent in bringing together complicated designs for constructing the interior of a building with pillars and arches and elaborate decoration.

During this period the art of opera developed into the showy costume performance that people still recognize today, and some of the grandest opera houses were built with luxuriously decorated interiors. The rococo style spread to the Catholic states of southern Germany and Austria, and some of the richest examples of the style are still to be found there. Rococo never became very popular in England or Italy, although the great Italian rococo painters who specialized in ceiling and wall decorations, such as Giovanni Battista Tiepolo (1696–1770), Sebastiano Ricci (1659–1734), and his nephew Marco Rizzi (1676–1729), often worked in other countries. To some people, rococo interiors are the most

The pictures on this page give three more views of the rich, decorative effects of rococo design. The decorated panel painted by Sebastiano Ricci (below) shows a heavenly scene with angels and cherubs framed with elaborate ornamental gilded plasterwork. *(San Marziale, Venice.)* The house façade in Wurzburg, Germany (right), shows how detailed design was sometimes added to the exterior of buildings. The Meissen porcelain bowl (below right) shows how amazingly skillful rococo craft workers were in creating intricate, beautifully decorated, delicate objects.

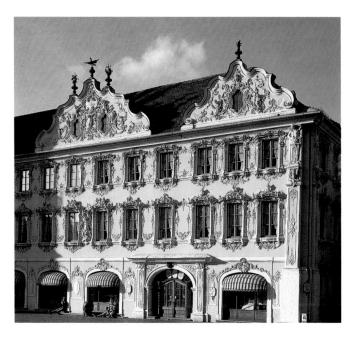

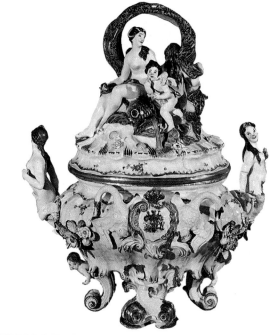

complete and beautiful expressions of European design; to others, they seem fussy and over-decorated.

One noticeable aspect of the rococo period, from the shimmering decorations to the intricate working of materials in smaller objects such as ceramics and furniture, is the fantastic skill that was employed in producing these effects. The rococo style is often likened to the beautiful and irregular appearance of shells, and with good reason. Such naturally occurring objects were at the time taken as examples upon which to base ideas for design. Curves, scrolls, and interweaving patterns abound, whether appearing on a silver chocolate pot, a piece of Meissen porcelain, the curved wooden legs of a chair, or the gold-covered plasterwork of a cornice.

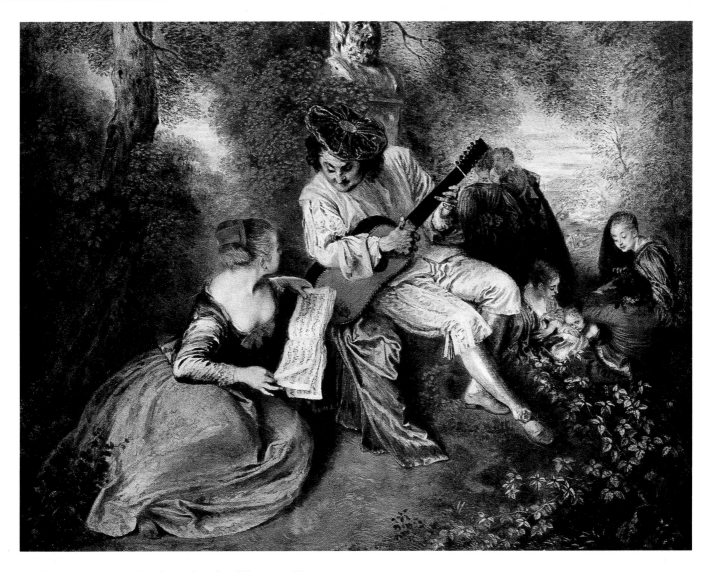

La Gamme d'Amour by Jean-Antoine Watteau. The artist's delicate style and the dreamy effect that he achieved perfectly suited the early rococo period, with its sense of life being removed from everyday reality. *National Gallery, London.*

An artist who was born in the Low Countries but who worked in France became one of the great painters of the early rococo style. Jean-Antoine Watteau (1684–1721) painted pictures of the easy life of leisure and pleasure that the wealthy French aristocrats of the early 1700s enjoyed. But he depicted this luxurious life in an almost dreamlike way. His delicate pictures show picnics, musical parties, and graceful men and women flirting in attractive and comfortable woodland settings. However, Watteau's paintings often convey a slight feeling of sadness, reminding the viewer that pleasures always come to an end. His work belongs to the period when members of the French aristocracy had gardens built with artificially created cascades of water drawn from streams, and they entertained their guests with nighttime outdoor concerts and firework displays.

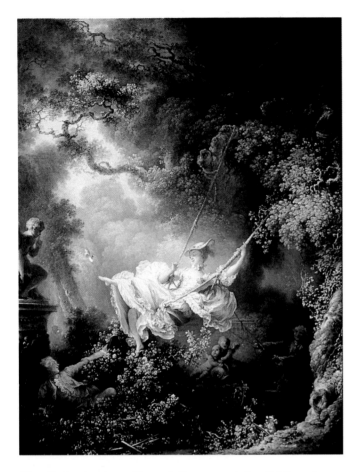

The Swing by Jean-Honoré Fragonard. As did Boucher (see page 6), Fragonard painted charming pictures of indulgent aristocrats. *Wallace Collection, London.*

Watteau created a way of seeing and a sense of style that influenced others, such as Nicolas Lancret (1690–1743). Later, in the 1700s, other artists used the delicate, decorative style of Watteau to make pictures that were intended to excite the sexual interest of viewers. Painters such as François Boucher (1703–1770) and Jean Honoré Fragonard (1732–1806) lacked the sad thoughtfulness of Watteau and were more interested in mischievous stories of love. As the eighteenth century wore on, it became evident, to some in France at least, that the price for this luxurious and wasteful lifestyle was too high. Heavy taxes collected from the middle classes and hardship for the working people were conditions that got worse as time went by. Many felt that the "dance" should be called to an end.

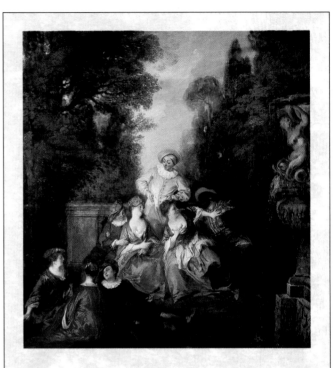

Commedia dell'arte

Commedia dell'arte is the name given to the popular drama of sixteenth-century Italy. It was a comical drama based on set characters and a few story lines. The actors would then make up the rest of the show as they went along. Gradually the traveling troupes of performers spread throughout Europe. The *commedia* provided the basis upon which later types of theater, such as English Punch and Judy and pantomime, were created. The *commedia* reached France in the second half of the seventeenth century and became especially popular among fashionable people in Paris. Some rococo artists such as Jean-Antoine Watteau and Nicolas Lancret often painted the French version of *commedia* characters such as Pierrot, Harlequin, and Columbine, which became known as the Comédie Française. *Italian Comedians by a Fountain* (above) was painted by Nicolas Lancret. The artist has composed this happy group of comedians in a pyramid shape, set in beautiful gardens.
Wallace Collection, London.

6 SENSIBLE ATTITUDES

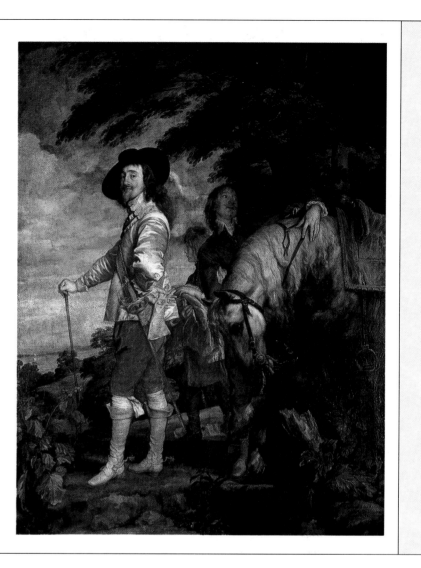

Charles I of England in Hunting Dress by Sir Anthony Van Dyck. This portrait shows the skills required of a court painter such as Van Dyck to create a grand representation of the subject. Van Dyck's methods set an example for British portrait painters for nearly two hundred years. *Musée du Louvre, Paris.*

Chapters 2 and 5 showed how in parts of Europe during the 1600s and 1700s the most popular style of art and design was elaborate, showy, and full of exaggerated feeling. In the Protestant areas of Europe, however, a much more serious attitude was to be found. The paintings of the "golden age" of Dutch art discussed in chapters 3 and 4 show that attitude.

England was another largely Protestant country. It had broken away from the power of the Pope in 1536, under King Henry VIII. There followed in England a long and terrible period of argument and violence that quieted down, for a time, during the reign of Queen Elizabeth I, but which eventually led to the Civil War (1642–1646). Throughout this period many of

the most famous and successful painters in England were artists who had been born and trained in northern Europe. Hans Holbein the Younger (c.1497–1543), from Germany, had been appointed court painter to Henry VIII. Later, Anthony Van Dyck (1599–1641), from Flanders, was court painter to Charles I; and Peter Lely (1618–1680), a Dutchman, was principal painter to Charles II after the King was restored to his throne. These three artists were mainly employed as portrait painters, and portraits continued to be the most popular form of art in England.

Artists of the late Baroque and early rococo style, such as the Riccis (see pages 25 and 26), sometimes went to England to decorate great houses with large-scale paintings on walls and

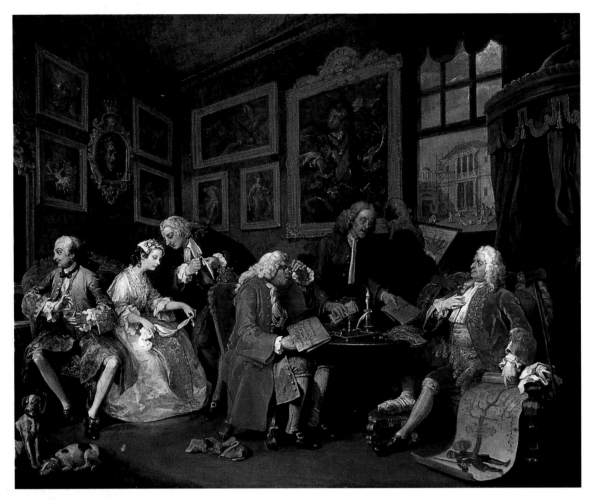

Signing the Marriage Contract from *Marriage à la Mode* by William Hogarth. *National Gallery, London.*

William Hogarth (1697–1764)

Hogarth was a very talented artist. His desire to overcome the artistic fashion of his day, the work of foreign artists over that of English artists, meant that he was always seeking new ideas. He may have been influenced by the work of Dutch genre paintings of the 1600s when he painted pictures that carried morals, criticizing people's bad behavior. These include his series paintings such as *A Harlot's Progress, A Rake's Progress, Marriage à la Mode* (see above), and other, similar, series. So that more people could see his pictures, Hogarth had engraved prints made. These could be easily copied and sold many times, quite cheaply.

ceilings. One of these was Burlington House in London. By the 1730s, however, one English artist was developing his work and his ideas in a way which reflected more "sensible" English attitudes.

William Hogarth (1697–1764) was a brilliantly skillful portrait painter who wanted to create a particularly English style of painting. He found a popular way of doing this in his sets of genre pictures, such as *A Rake's Progress*, of which many engraved prints were sold. Like Dutch genre pictures, Hogarth's always had a message about good and bad behavior and usually the series told a story step-by-step, like chapters in a book or scenes in a play. Other artists were influenced by Hogarth's lively, down-to-earth approach, including Johann Zoffany

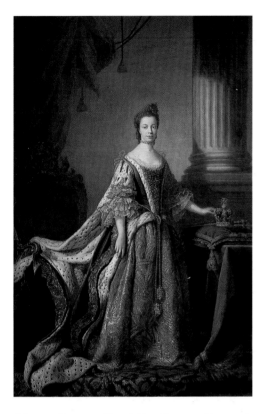

Above *Queen Charlotte, Queen Consort of George III* by Allan Ramsay. *Guildhall, London.*

Right *Portrait of a Girl* by Sir Joshua Reynolds. *Agnew and Sons, London.*

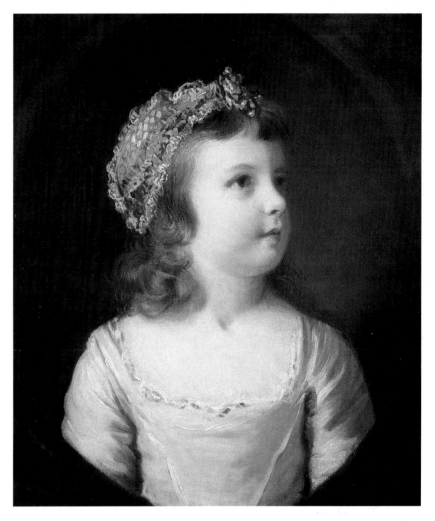

(c.1733–1810), a German-born artist who made a reputation in England as a painter of actors and theatrical scenes.

Hogarth never quite won over the wealthy and powerful people who set the fashion for art in England, and his idea for an "English School" of painting was not seriously taken up until after his death. The Royal Academy was set up in London in 1768 as an organization that would train new artists in the formal skills of the arts and give to its members a position of respectability and achievement. The first President of the Academy was Joshua Reynolds (1723–1792), who had studied the Italian masters in Rome and Venice and who wrote and lectured on the tradition of painting he found there. Despite his ideas and interests

Reynolds found very few customers for the kind of pictures – of carefully composed "history" subjects – he preferred to paint. History paintings were usually subjects taken from classical mythology, the Bible, or great events in actual history.

Most of Reynolds's work, in fact, came in the form of commissions from wealthy people for portraits. As a result, he began to specialize in portrait painting. Many other famous artists of Reynolds's time were also portrait painters. Several notable examples were Scottish, such as Allan Ramsay (1713–1784) and Henry Raeburn (1756–1823), and one was a Swiss-born woman, Angelica Kauffmann (1741–1807), who was one of the first members of the Royal Academy.

7 TOWN AND COUNTRY

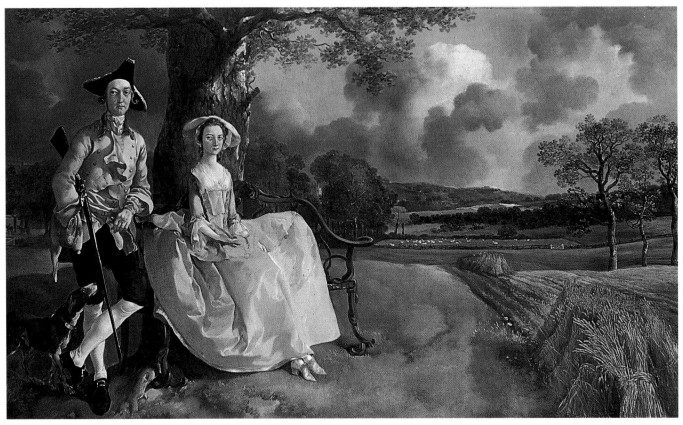

Robert Andrews and Mary, his Wife by Thomas Gainsborough. In this painting two sides of Gainsborough's career as an artist are apparent: one as a portrait painter and the other as a landscape painter. Here these two sides blend together as the wealthy landowners, Mr. and Mrs. Andrews, wished to be painted against a "portrait" of their farmland. *National Gallery, London.*

One English artist of this period was seen by many as Joshua Reynolds's greatest rival, and he too discovered that to make a good living from painting he had to produce portraits for the wealthy. Thomas Gainsborough (1727–1788) came from Suffolk, England, and would probably have preferred to spend his life painting pictures of the countryside rather than making flattering portraits of important customers. In one of his early works (above) he showed his patrons, Mr. and Mrs. Robert Andrews, in the foreground of a large landscape view, which includes their rolling farmland disappearing into the distance in beautiful detail.

Throughout the 1700s the idea that the landscape was a worthy subject for painting was very gradually catching on in England. There were a number of reasons for this, one being a growing appreciation of the Dutch landscape painters, whose achievement had reached a high point in the later part of the 1600s, with artists such as Ruisdael, Hobbema, and Cuyp. Certainly these painters had an influence on artists such as Gainsborough. But other events also played their part. Through the troubling times of the Civil War, during the period known as the Commonwealth – when the monarchy had been deposed in England –

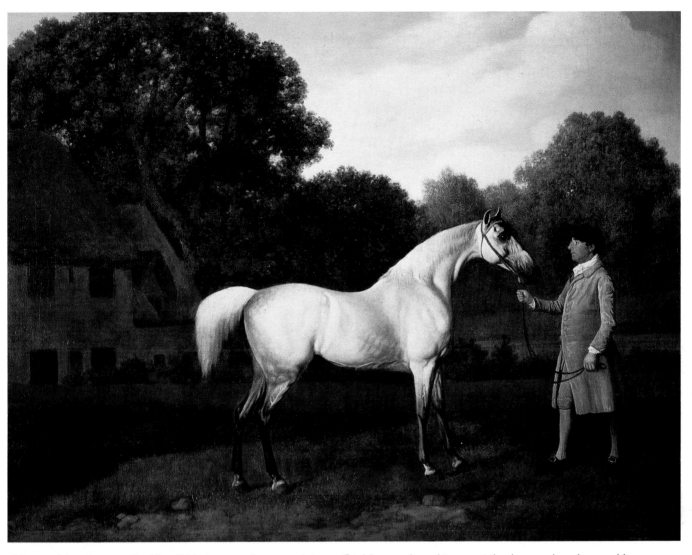

Gimcrack by George Stubbs. This is one of many pictures Stubbs produced to meet the increasing demand in England for paintings of sporting subjects. *Private collection.*

a large number of wealthy noblemen retreated from London and other large towns to their country estates. Here they enjoyed sporting activities such as horse racing and hunting. This was reflected in a growing interest for pictures of these themes, by artists such as John Wootton (1682–1764) and George Stubbs (1724–1806).

Toward the end of the seventeenth century a fashion sprang up among the landed gentry for impressive country mansions built to supposedly classical rules, usually as laid down by the Italian Renaissance architect

Palladio. To suit these grand buildings, classical settings were required, and landscape gardeners such as Lancelot "Capability" Brown (1715–1783) were employed to design and construct such views in enormous parklands. Often, works by landscape artists, especially Claude (see page 14), would be consulted for ideas about how these classical landscapes should look.

The growing interest in the look of the landscape led to the appearance in the 1700s of artists who concentrated upon landscape subjects for their own sake. The best and

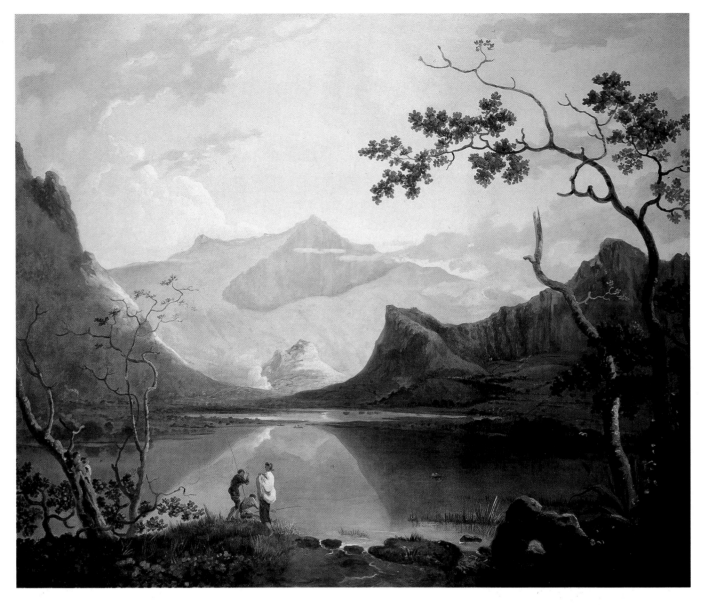

Snowdon by Richard Wilson. Wilson was one of the first artists in Great Britain to make a career out of painting landscapes. This majestic view of Mount Snowdon in North Wales is set off by the carefully arranged frame formed by the dip in the mountain ridge in the middle distance. *Norwich Castle Museum.*

earliest of these was the Welsh artist Richard Wilson (c.1713–1782), who painted majestic but realistic views in southern England and the mountains of North Wales. Other painters worked in a style known as "topographical" (the accurate recording of the appearance of a place). More and more people were becoming fascinated by the idea that looking at beautiful scenery could improve the mind. Tourism began to develop as a practical way of seeking such experiences for the well-off, and paintings – the visual records of such views – became ever more desirable. This led, toward the end of the 1700s, to the greatest period of English landscape painters, which included J. M. W. Turner, Thomas Girtin, John Sell Cotman, John Constable, and many others. You can read about these artists and their works in *Art in the Nineteenth Century*, another book in this series.

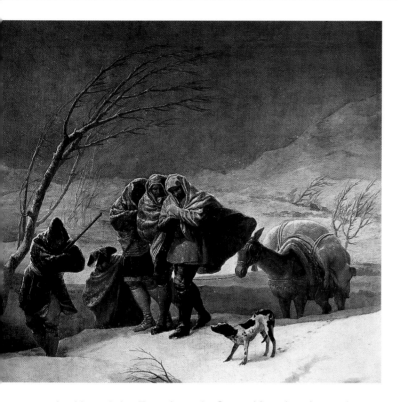

La Nevada by Francisco de Goya. Here he shows a group of travelers trudging through bitter mountain weather. Even in Goya's early work the darker side of life began to appear. *Museo de Prado, Madrid.*

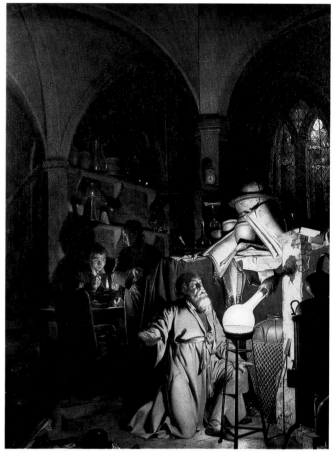

The Alchemist by Joseph Wright of Derby. Wright's painting is very different from Wilson's outdoor landscape (opposite). This picture shows an indoor scene at night. Like the followers of Caravaggio in the previous century, the artist has lit his subject from the center with artificial light. Scientific experiments were one of Wright's favorite themes. *Derby Museum and Art Gallery, England.*

Francisco de Goya (1746–1828)

Goya was born in a small village in northern Spain. He was ambitious, and during his lifetime he achieved great success as an artist. He was asked to produce designs for the Royal Tapestry Factory at Madrid. Later he became a successful portrait painter to the rich and then principal painter to the Spanish king. Goya's early work showed everyday life in Spain, but it also showed the darker side of his character, which became more pronounced in later life. He suffered from an unhappy love affair, became deaf after an illness, and witnessed the horrors of the Napoleonic wars in Spain. All these tragic experiences affected his art. Some of Goya's later work, known as the "Black Paintings" because of their dark colors and sinister subjects, show imaginary scenes of horror such as witchcraft and cannibalism. *La Nevada*, above, was painted in 1786-87.

The growing influence of the Industrial Revolution, which was taking place through the 1700s, eventually brought about an enormous change in English life. More and more people were leaving the countryside to settle in the towns where there was work. This explains to some extent why people had become so fascinated by the landscape and the pleasures of looking at nature. People were living away from the countryside, in towns that

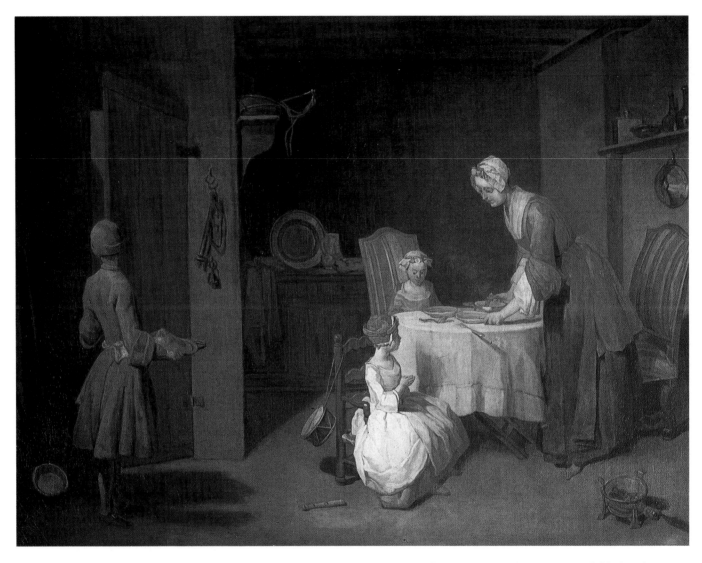

Saying Grace by Jean-Baptiste-Siméon Chardin. This painting, like *The Scullery Maid* on the cover of this book, shows us Chardin's fascination with the small events of life. His pictures of domestic scenes and still lifes show the differences between the textures of substances, as Dutch painters had done earlier. *Museum Boymans-van Beuningen, Rotterdam.*

were rapidly increasing in size and becoming filthy with the effects of industry. One artist who celebrated science and the scenes of industry was Joseph Wright of Derby (1734–1797). He was so-called because he remained in his local town, which was unusual for a professional artist at that time. Wright, whose patrons were mostly those who had recently made their money from the new industries in the region, used strong, dramatic lighting. He was a follower of Caravaggio (see chapter 2).

Although England was a focus through this period for the "sensible" attitudes, as shown in the interest in genre, portrait, landscape, and sports pictures, it was by no means the only place where such ideas were to be found. Despite the showiness of late rococo art, there were artists in France in the middle of the

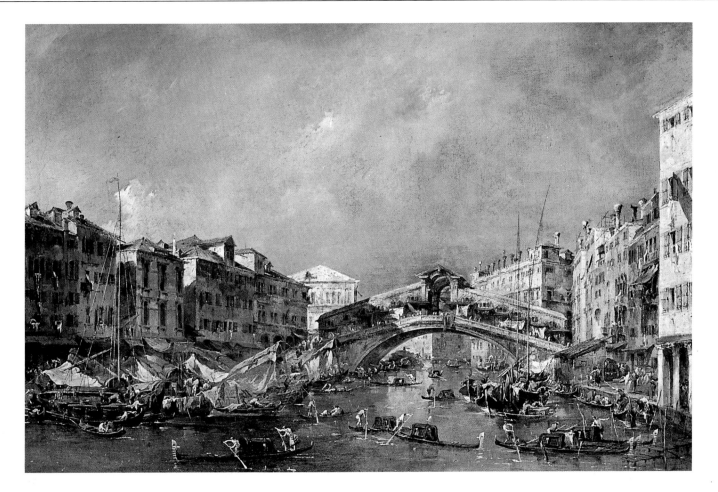

Venice, the Grand Canal by Francesco Guardi. The demand for pictures of recognizable places grew rapidly in the eighteenth century with the increase of tourism among the wealthy. Not surprisingly, Venice was a popular subject for such paintings. *San Diego Museum of Art.*

1700s who focused upon the morals of everyday life. The most important of these was Jean-Baptiste-Siméon Chardin (1699–1779), whose small still lifes and views of the home are quietly impressive, with their attention to detail and ability to describe the textures of ordinary things. Other French artists painted larger, more elaborate pictures to make moral points, such as Jean-Baptiste Greuze (1725–1805).

In Italy, artists called *Vedutisti* developed the topographical tradition, specializing in views of towns. The most famous of these artists were Giovanni Antonio Canal Canaletto (1697–1768) and Francesco Guardi (1712–1793), who both came from Venice. In Spain, in his early career, Francisco de Goya (1746–1828) concentrated on scenes from everyday life and portraits that were renowned for their honesty and realism (see page 35).

8 A NEW WORLD

The "New World" of the Americas was first visited by Europeans when the Italian explorer Christopher Columbus sailed on an expedition in 1492, paid for by the Spanish monarchs Ferdinand and Isabella. Soon, the Americas became the focus for much activity from European countries. These "new found" lands offered strange products such as potatoes and tobacco and the promise of enormous wealth, especially through the capture of gold from the native peoples already living there. In many ways the early history of the European conquest of the Americas is a shameful story, leading to the deaths of huge numbers of the native peoples and the destruction of their ways of life. The Spanish were particularly successful in obtaining riches from South America, and English ships had some success in stealing the gold from them as they brought it back to Europe. By the eighteenth century there were settlers from many European countries in North America, all competing for land and the resources it could offer. The Dutch, French, and English had all set up

Left *Woman and Children*, Anonymous. The unknown portrait painters of European North America often made pictures in an attempt to copy the way trained artists painted portraits in Europe. Here, the artist has painted a beautiful picture, framed with a decorative border of curtains and plants, but the scale of the different subjects to each other is a little odd. *Philadelphia Museum of Art.*

Right *Mrs. Samuel Chandler* by William Chandler. Although Chandler's painting clearly shows he had a better understanding of how to portray his subject in the European way than the artist who painted the picture on the left, his portrait is still a little stiff and awkward. Notice he has also used a curtain to frame his subject. *National Gallery of Art, Washington, D.C.*

colonies, but others came from Spain, Germany, Sweden, and later from all over Europe.

The early colonists in North America could afford little time or interest for art, although there was a small demand for portraits in the seventeenth century. Many of the settlers who left Europe for America were Puritans, escaping from the religious persecutions that continued even in Protestant countries like England. Puritan belief forbade luxurious living and even considered the making and owning of

pictures to be an idle and harmful pursuit. These attitudes, together with the very difficult life in the colonies, slowed down the demand for art. The early portraits, often made by artists who had had no formal training in the style of European painting, were small in scale and are often called "limner" (little) paintings. Mostly the artists who made these pictures remained unknown, since they usually did not sign their work, but in more recent years some interesting examples have become famous, such as the portrait of Mrs. Chandler by

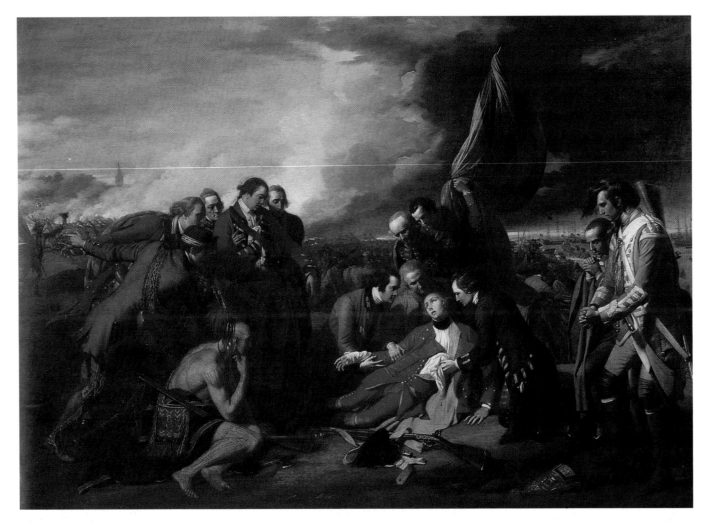

Death of Wolfe by Benjamin West. This picture of the death of General James Wolfe depicts a historical event in an obviously artificial scene. The figures are carefully arranged around the central subject with as much dramatic effect as possible. This kind of "history" painting was much admired in England and France at the time.
National Gallery of Canada, Ottawa.

William Chandler. Mr. Chandler had obviously seen the way European portraits were made, possibly from engraved prints, and had copied the position in which the subjects were placed in the picture, but his technique was rather stiff.

As the colonies gradually became richer, artists who had been trained in Europe ventured to the "New World" in search of work. John Smibert (1688–1751) was born in Scotland and traveled to the West Indies as well as to the British colonies in North America. He set up a studio in Boston, and for years after his death young American artists visited his collection of pictures and plaster casts to learn about painting. Other European artists, especially from England and the Netherlands, came to the colonies and settled, passing on their knowledge and skills to younger painters born there. Benjamin West (1738–1820) and John Singleton Copley (1738–1815) were two such American artists. West had early training from an English painter in Pennsylvania, then went

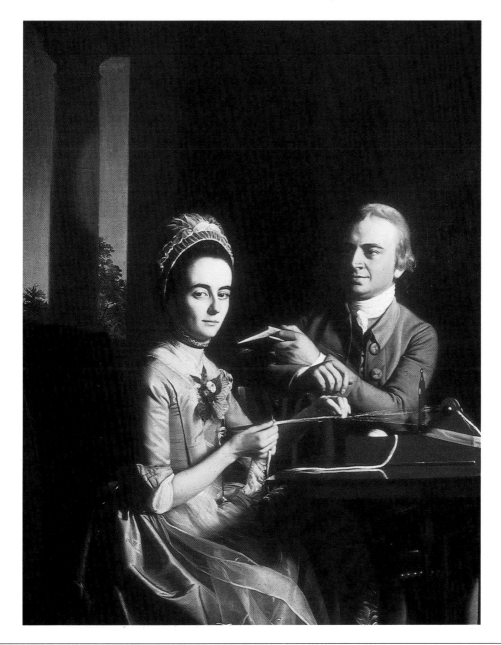

Governor and Mrs. Thomas Mifflin by John Singleton Copley. Like Benjamin West, Copley also began his training in the American colonies. As we see in this portrait, he developed an extremely vivid, lifelike style of painting, which he used to portray his New England patrons. He later traveled to Italy and settled in England, where he too developed the methods of "history" painting, producing large, dramatic canvases showing recent events. *Historical Society of Pennsylvania, Philadelphia.*

to Philadelphia where he learned more from another English painter, John Wollaston. Later he traveled to Italy to study art, and finally he ended up in London, where he was so successful that he followed Reynolds as the second President of the Royal Academy. Copley learned about painting in Boston, where he was born, and only after he had achieved considerable success did he move to England. Both men, like most other artists of their day, began their careers making portraits – those by Copley are remarkably powerful. To make a

reputation for painting other kinds of subjects, however, they had to go to Europe to find interested patrons.

Many younger American painters, such as Charles Willson Peale (1741–1827) and Gilbert Stuart (1755–1828), went to London to train with West before returning to work in the new country of the United States of America, which declared Independence from British rule in 1776. Peale was founder of not only one of the most active families of artists in the United

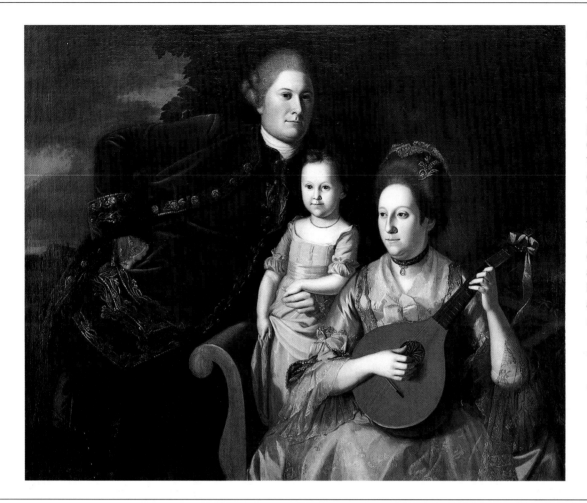

Mr. and Mrs. Lloyd with Family by Charles Willson Peale. Peale studied under West and painted portraits of leading contemporary figures. But, compared with Copley's painting on page 41, his figures are stiff and lifeless. He excelled less as an artist than with all his other interests and achievements. *H. F. du Pont Winterthur Museum, Wilmington, Delaware.*

States, but also of the first American academy of art in Philadelphia and the first science museum in the country. Several of his children, of whom there were seventeen, also became successful painters and were named after famous European artists; Raphaelle, Rembrandt, Rubens, Titian Ramsay, and Angelica Kauffmann Peale. His brother James was also a painter, of miniatures, and likewise had several children who became artists.

The nineteenth century was an exciting time for the development of art in America, and various groups of artists became successful and famous for a variety of subjects, such as the Hudson River School for landscapes and the Philadelphia School of still-life painters. You can read about some of these artists in *Art in the Nineteenth Century.*

The arts of Native Americans
When Europeans first came to the Americas with the arrival of Columbus in 1492, people had already been living there for thousands of years. Because Columbus thought he had sailed all the way around the world to India, the Europeans called these people "Indians." There were many Native American peoples, from the Inuit in the north to the Incas in the south. Native American peoples lived all over the Americas and their arts were as varied as the lands they inhabited. They carved in wood, stone, bone, and ivory; embroidered cloth; drew on rocks; and painted with sand, making use of all sorts of natural materials. Unfortunately, many of the Native Americans' traditional skills have been lost forever, as European settlers have changed their ways of life.

9 PAST, PRESENT, AND FUTURE

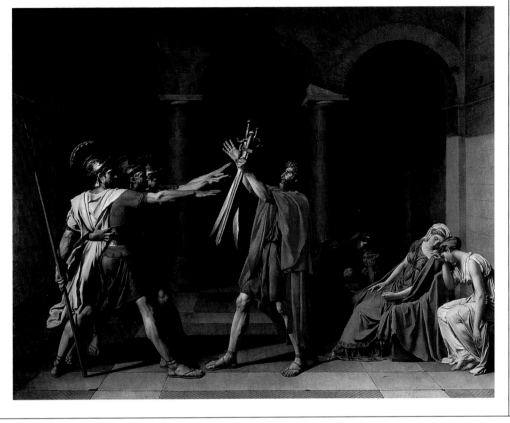

The Oath of the Horatii by Jacques-Louis David. In 1785, when it was painted, David's dramatic painting was believed by some people to be a call to the French people to overthrow the corrupt rule of the monarchy and establish a republic. In fact, this came about within the next few years. The picture's powerful composition conveys a tense feeling just right for its violent subject. *Musée du Louvre, Paris.*

As the eighteenth century drew to a close, great events changed the pattern of life, and consequently the arts, in the Western world. America's victorious Revolutionary War fought against the British encouraged the anger of people in France (which had sided with the American colonists) about the unfairness of life in their own country. In the mid-1700s, new discoveries about classical Greece and Rome were made at Pompeii and Herculaneum in Italy, and these discoveries made a great impression upon artists of the time. The German art historian Johann Winckelmann (1717–1768) published an important book about classical art and his ideas were a strong influence on the work of the German artist Anton Raphael Mengs (1728–1779), who adopted his neoclassical ideas. Winckelmann's influence was spread throughout Europe by Mengs's work.

Some of the same fascination for classical ideas and techniques can be seen in the work of the French artist Joseph Vien (1716–1809) and appears most strongly in the works of the great French painter Jacques-Louis David (1748–1825). In 1785, David painted *The Oath of the Horatii*. It is a powerful and simplified image of three ancient heroes swearing loyalty to the Roman Republic. Afterward, many people regarded this picture as a call to overthrow the French king and set up a republic ruled by elected representatives. In 1789 the French Revolution began and David became closely involved with the confusing and violent events that followed. He established a new *Institut* to replace the French Academy and was a tremendously influential teacher of painting, affecting some of the most famous artists of the next generation.

Portrait of a Woman as a Vestal by the Swiss artist Angelica Kauffmann. She was influenced by neoclassical art and later found success in England as a portrait painter. *Gemüldegalerie, Alte Meister, Dresden, Germany.*

Left *Girl with a Dove* by Anton Raphael Mengs. This simple portrait gives little clue as to the fame and influence achieved by Mengs. *Pollock House, Glasgow, Scotland.*

Greco-Roman painting

The interest in all things classical in the latter part of the eighteenth century was greatly influenced by the recent findings at the ancient Roman sites of Pompeii and Herculaneum. The remarkable paintings found at the sites are usually described as Greco-Roman because the style used had been developed by Greek artists but was spread through the Roman Empire after Greece was swallowed up in 147 B.C. Some of the paintings are frescoes, made directly on walls. Others were painted on wooden panels with a kind of wax paint. The lively portraits and clever use of visual tricks show how imaginative the painters of that time were. These qualities inspired later artists to revive the arts of classical times.

The style of artists such as Mengs and David, and later J. A. D. Ingres (1780–1867), who were influenced by the art of ancient Greece and Rome was called neoclassicism. This style was accompanied by a widespread fashion for all things classical: architecture, clothing, and even military ambition, as Napoleon Bonaparte showed when he established himself as the ruler of a French Empire, which he wished to equal that of the Roman Emperor Julius Caesar. The neoclassical age, while looking back to the ancient past, seemed to want to create a new classical world in the present.

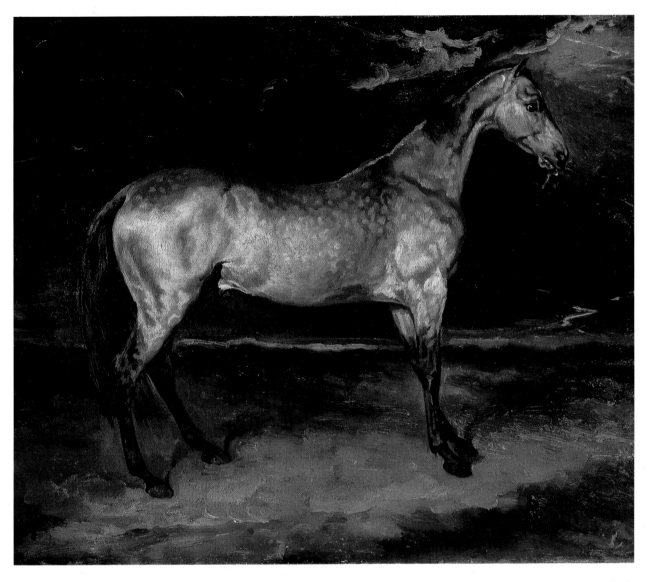

A Horse Frightened by Lightning by Théodore Géricault. Géricault painted this dramatic picture of the terrified horse partly as a reaction to the precision of neoclassical artists. *National Gallery, London.*

The excitement of these times found a new expression in the ideas that were already taking hold in various parts of Europe. What became known as the Romantic era in European art was already appearing in the work of landscape painters, who turned their backs on civilized, modern cities to look for a different kind of truth in the wildness of nature. Other artists were using ideas from the so-called Dark Ages of Europe, before the Renaissance, working in a style that became known as the Gothic Revival. Some artists were turning to personal beliefs and visions, as can be seen in the work of William Blake (1757–1827) in England, Caspar David Friedrich (1774–1840) in Germany, and the later works of Goya in Spain. French artists such as Antoine-Jean Gros (1771–1835) and Théodore Géricault (1791–1824) began painting themes that were based upon the excitement and drama of the moment, often depicting extreme and violent activities.

The nineteenth century continued as it began, with great contrasts and rapid changes both in life and in art.

GLOSSARY

Atmospheric (in art) Having a moody feeling.
Baroque A style of art and architecture that flourished in Europe from the late sixteenth to early eighteenth centuries. The style was dramatic and ornate, appealing strongly to the emotions.
Cannibalism The act of humans eating human flesh.
Classical Relating to the ancient Greeks and Romans.
Commission A request or order for a work of art for which a fee will be paid.
Commonwealth See English Civil War (below).
Cornice A decorative molding projecting from the top of a wall or building.
Counter-Reformation The movement to reform the Roman Catholic Church in the sixteenth and early seventeenth centuries. The movement was set up to counteract the Reformation (see below).
Democracy A system of rule in which the government has been freely elected by the people.
English Civil War A conflict between Charles I and Parliament (between 1642–1646). The King was executed in 1649 and England became a Commonwealth, or republic, led by Oliver Cromwell. In 1660 the monarchy was restored under Charles II.
Engraved prints Prints taken from an engraved (cut) hard surface such as metal or wood.
French Revolution The violent uprising in France of 1789 when the monarchy was overthrown and the country became a republic.
Genre picture A painting or drawing of a domestic scene or everyday activities.
Genres Types or categories, especially in literature or art.
Gothic Revival An artistic style in the nineteenth century that imitated medieval ideas, art, and architecture.
Industrial Revolution The process by which Great Britain and other European countries changed, during the eighteenth and nineteenth centuries, from being mainly agricultural to mainly industrial nations.
Landscape A picture of the countryside.
Low Countries An old name for the low-lying countries bordering the North Sea, which were once part of the Spanish Empire. They consisted of the Netherlands, present-day Belgium, and Luxembourg.

Miniature A small painting, especially a portrait, showing very fine detail.
Moral Concerned with the distinction between right and wrong.
Mythological Relating to stories and beliefs associated with a particular culture.
Neoclassicism A style of art of the late eighteenth and early nineteenth centuries based on the imitation of ancient Greek and Roman ideas and architecture.
Patrons People who encourage and support artists.
Plaster cast A copy or mold of a sculpture cast in plaster of paris.
Portraiture The art of making recognizable pictures or sculptures of particular people.
Puritans Strict Protestants who disapproved of the pleasures in life. They were often persecuted even by other Protestant religions in their own countries. Many sailed to North America, where they were able to worship in their own way.
Realism A style of painting and sculpture that seeks to represent real life, rather than an idealized or romantic view of it.
Reformation A religious movement in sixteenth-century Europe critical of the Catholic Church that resulted in the establishment of the various Protestant churches.
Religious persecution Ill-treatment and oppression of people because of their religion.
Rococo A style of architecture and design, originating in France in the eighteenth century, characterized by elaborate decorative curves and scrolls.
Romantic art A style of art of the late eighteenth and early nineteenth centuries characterized by an emphasis on emotions and feeling.
Royal Academy A society founded in London in 1768 to improve the status of artists and standards of painting, sculpture, and design in England.
Still life A painting or drawing of inanimate objects such as flowers, fruit, books, etc.
Technique Method or skill.
Textures The feel of the surface of objects and how this is represented in art.
Three-dimensional Having depth as well as height and width.
Topography The study or detailed description of the surface features of a region.

FURTHER READING

American Heritage Illustrated History of of the United States, Vol. 2: Colonial America. Reprint of 1963 edition. Westbury, NY: Choice Pub NY, 1988.

Bonafoux, Pascal. *A Weekend with Rembrandt.* New York: Rizzoli International, 1992.

Carlin, Richard. *European Classical Music 1600-1855.* New York: Facts on File, 1988.

Harris, Nathaniel. *Renaissance Art.* Art and Artists. Thomson Learning, 1994.

Janson, H. W. and Janson, Anthony F. *The History of Art for Young People.* 4th edition. New York: Harry N. Abrams Inc., 1992.

Roalf, Peggy. *Horses.* Looking at Paintings. New York: Hyperion, 1992.

Roalf, Peggy. *Landscapes.* Looking at Paintings. New York: Hyperion, 1992.

Shissler, Barbara. *The New Testament in Art.* Minneapolis: Lerner Publications, 1970.

Stepanek, Sally. *Martin Luther.* World Leaders – Past and Present. New York: Chelsea House, 1986.

Waldron, Ann. *Francisco Goya.* New York: Harry N. Abrams Inc., 1992.

For younger readers

DISCOVERING ART series by Christopher McHugh (New York: Thomson Learning, 1993).

GETTING TO KNOW THE WORLD'S GREATEST ARTISTS series by Mike Venezia (Chicago: Childrens Press, 1988 – 1993).

WHERE TO SEE SEVENTEENTH- AND EIGHTEENTH-CENTURY ART

The following list of museums includes some of the most important American museums for viewing art of the Western world.

Baltimore
The Baltimore Museum of Art
Art Museum Drive
Baltimore, MD 21218
(301) 396-7101

Boston
Museum of Fine Arts
465 Huntington Avenue
Boston, MA 02115
(617) 267-9300

Chicago
The Art Institute of Chicago
Michigan Avenue at Adams Street
Chicago, IL 60603
(312) 443-3600

Cincinnati
Cincinnati Art Museum
Eden Park
Cincinnati, OH 45202
(513) 721-5204

Cleveland
Cleveland Museum of Art
11150 East Boulevard
Cleveland, OH 44106
(216) 421-7340

Houston
The Museum of Fine Arts
1001 Bissonet
Box 6826
Houston, TX 77265
(713) 639-7300

New Haven
Yale Center for British Art
1080 Chapel Street
Box 2120
New Haven, CT 06520
(203) 432-2800

New York
The Metropolitan Museum of Art
Fifth Avenue at 82nd Street
New York, NY 10028
(212) 879-5500

Philadelphia
Philadelphia Museum of Art
26th Street and Benjamin
 Franklin Parkway
Philadelphia, PA 19101
(215) 763-8100

San Francisco
The Fine Arts Museums of California
M. H. deYoung Museum
Lincoln Park
San Francisco, CA 94121
(415) 750-3600

San Marino
Huntington Library, Art Collections,
 and Botanical Garden
1151 Oxford Road
San Marino, CA 91108
(818) 405-2100

Washington D.C.
The National Museum of
 American Art
Smithsonian Institution
8th and G Streets, NW
Washington, DC 20560
(202) 357-2700

INDEX